436 total dots

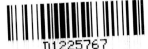

⚠ = Begin a new line section.

⊙ = Pick up your pen/pencil and look for the next sequential
number with the small triangle symbol next to it.

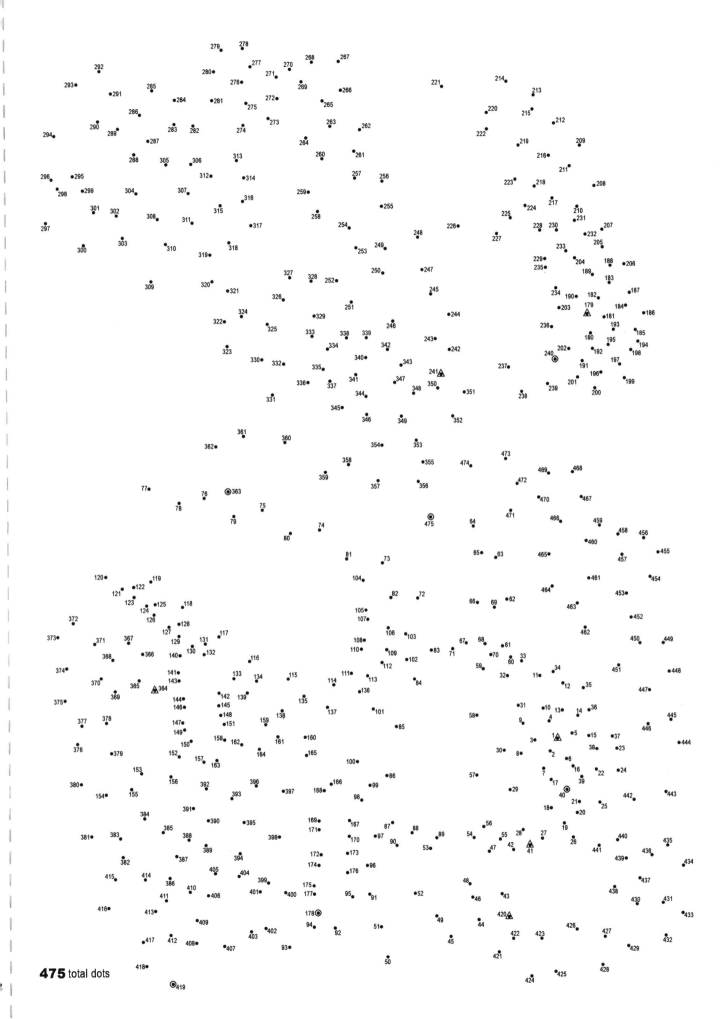

475 total dots

⚠ = Begin a new line section.

⊙ = Pick up your pen/pencil and look for the next sequential
number with the small triangle symbol next to it.

395 total dots

◭ = Begin a new line section.

◉ = Pick up your pen/pencil and look for the next sequential
number with the small triangle symbol next to it.

415 total dots

△ = Begin a new line section.

◉ = Pick up your pen/pencil and look for the next sequential
 number with the small triangle symbol next to it.

450 total dots

⚠ = Begin a new line section.

⊙ = Pick up your pen/pencil and look for the next sequential
number with the small triangle symbol next to it.

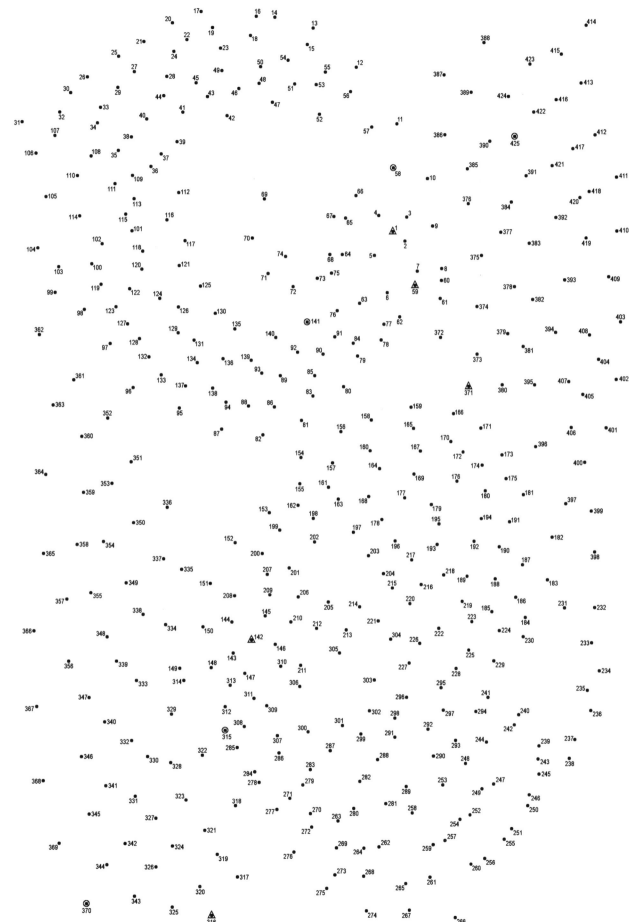

425 total dots

⚠ = Begin a new line section.

◉ = Pick up your pen/pencil and look for the next sequential
number with the small triangle symbol next to it.

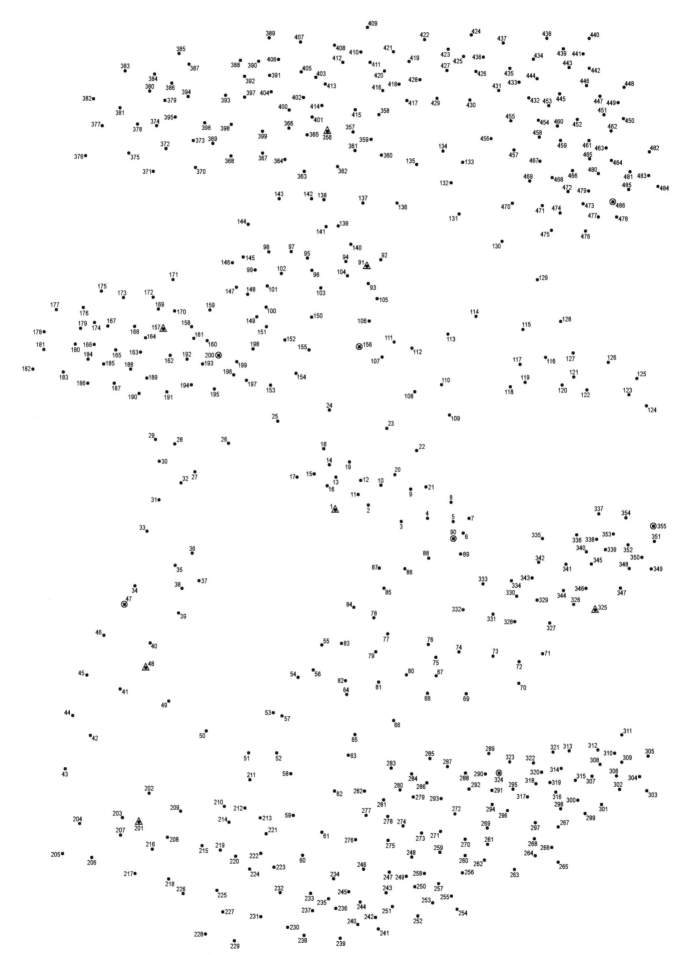

486 total dots

△ = Begin a new line section.

⊙ = Pick up your pen/pencil and look for the next sequential
number with the small triangle symbol next to it.

417 total dots

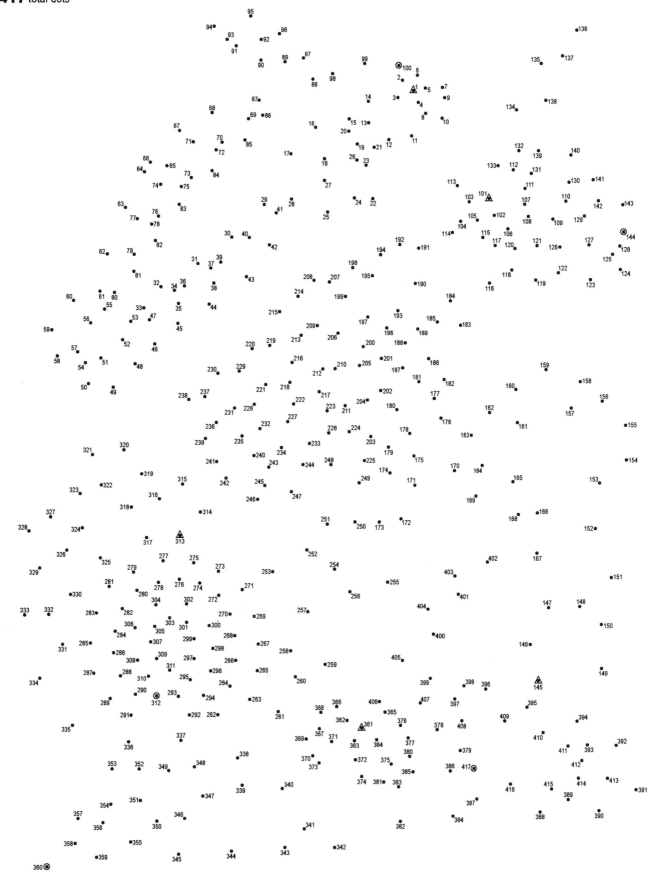

⚠ = Begin a new line section.

◉ = Pick up your pen/pencil and look for the next sequential
number with the small triangle symbol next to it.

400 total dots

▲ = Begin a new line section.

◉ = Pick up your pen/pencil and look for the next sequential
number with the small triangle symbol next to it.

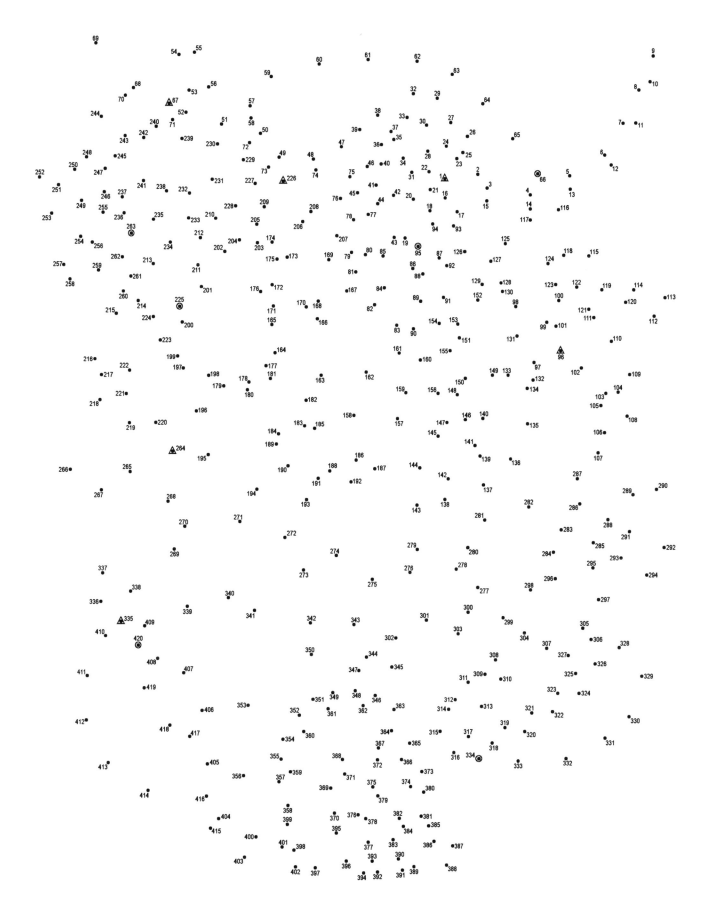

420 total dots

△ = Begin a new line section.

⊙ = Pick up your pen/pencil and look for the next sequential
number with the small triangle symbol next to it.

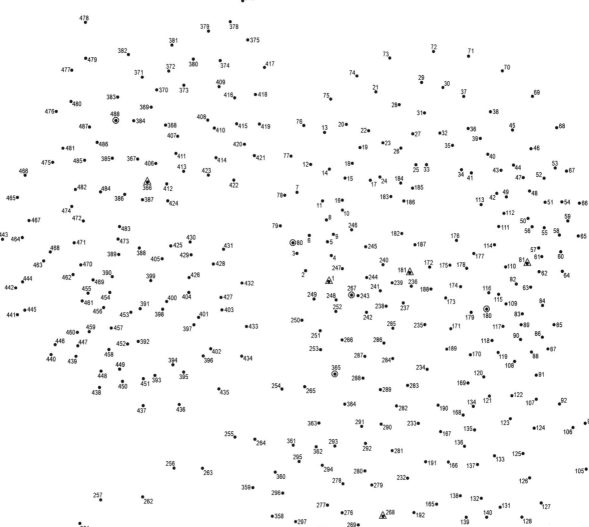

⚠ = Begin a new line section.

⊙ = Pick up your pen/pencil and look for the next sequential
 number with the small triangle symbol next to it.

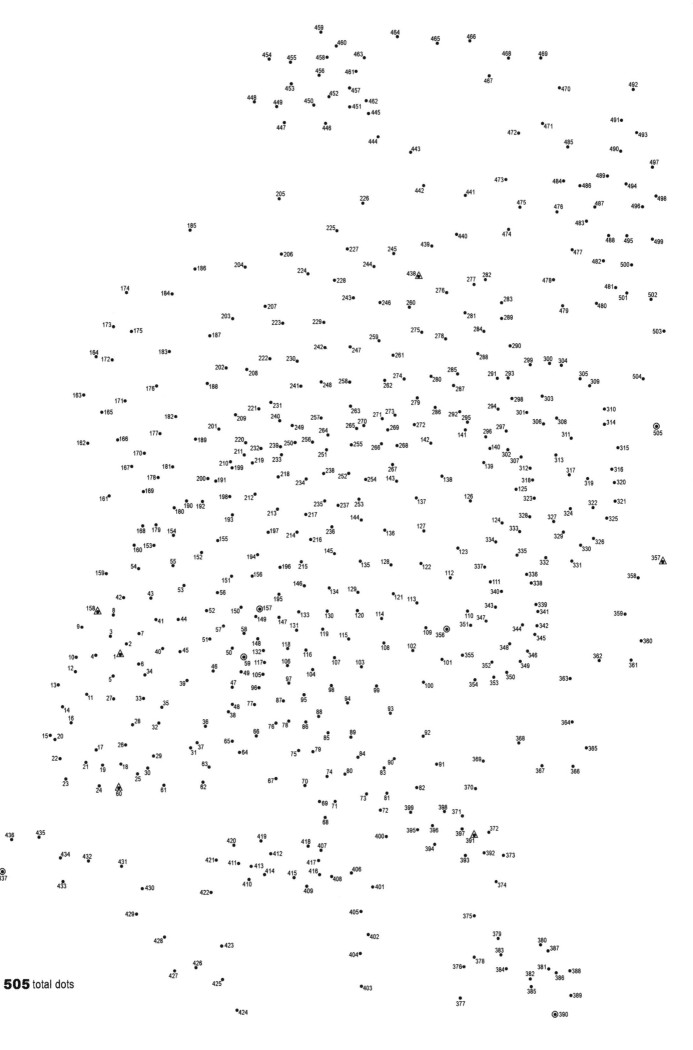

505 total dots

⚠ = Begin a new line section.

⊙ = Pick up your pen/pencil and look for the next sequential
number with the small triangle symbol next to it.

425 total dots

⬛ = Begin a new line section.

◉ = Pick up your pen/pencil and look for the next sequential
number with the small triangle symbol next to it.

500 total dots

△ = Begin a new line section.

⊙ = Pick up your pen/pencil and look for the next sequential
number with the small triangle symbol next to it.

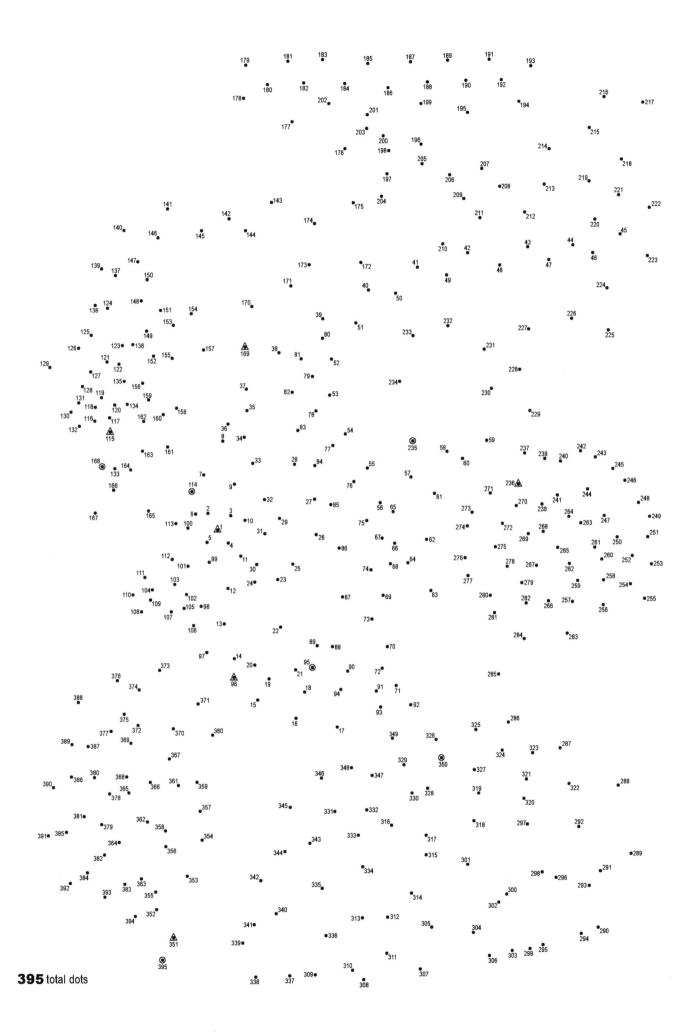

395 total dots

⚠ = Begin a new line section.

⊙ = Pick up your pen/pencil and look for the next sequential
number with the small triangle symbol next to it.

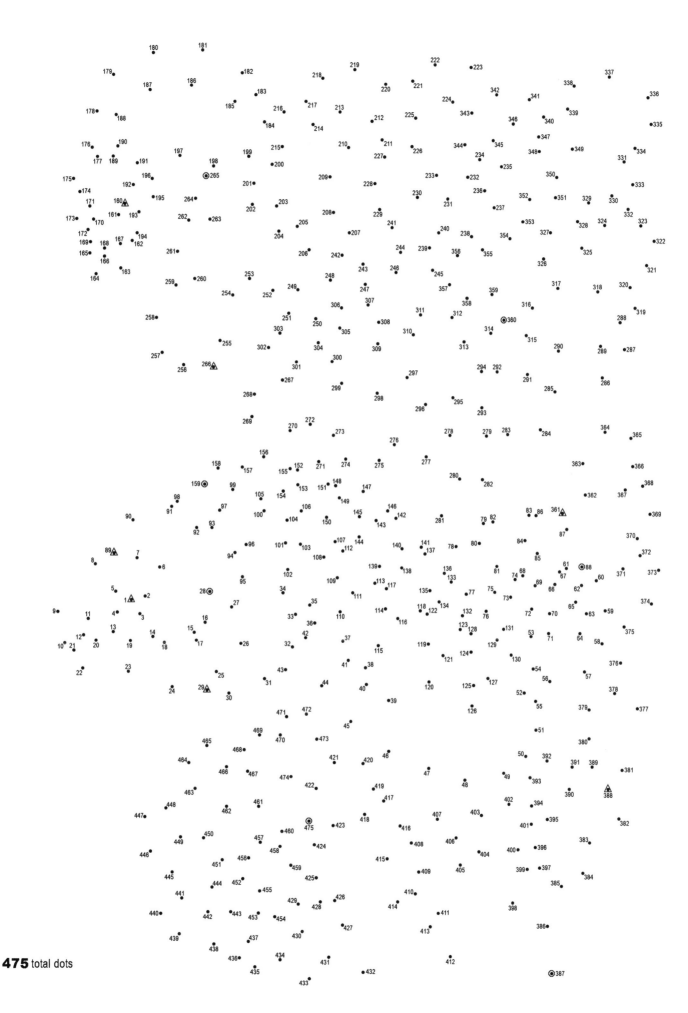

475 total dots

⚠ = Begin a new line section.

◉ = Pick up your pen/pencil and look for the next sequential
number with the small triangle symbol next to it.

488 total dots

⚠ = Begin a new line section.

⊙ = Pick up your pen/pencil and look for the next sequential
number with the small triangle symbol next to it.

381 total dots

⚠ = Begin a new line section.

⊙ = Pick up your pen/pencil and look for the next sequential
number with the small triangle symbol next to it.

425 total dots

⚠️ = Begin a new line section.

◉ = Pick up your pen/pencil and look for the next sequential
 number with the small triangle symbol next to it.

420 total dots

△ = Begin a new line section.

⊙ = Pick up your pen/pencil and look for the next sequential
number with the small triangle symbol next to it.

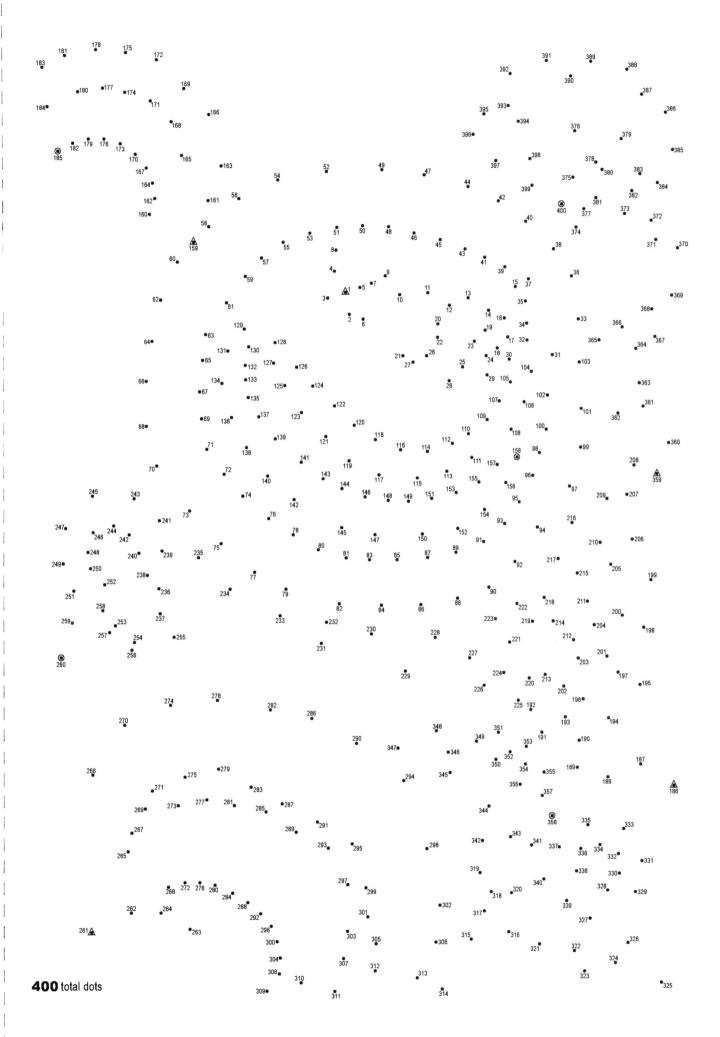

400 total dots

⚠ = Begin a new line section.

⊙ = Pick up your pen/pencil and look for the next sequential
number with the small triangle symbol next to it.

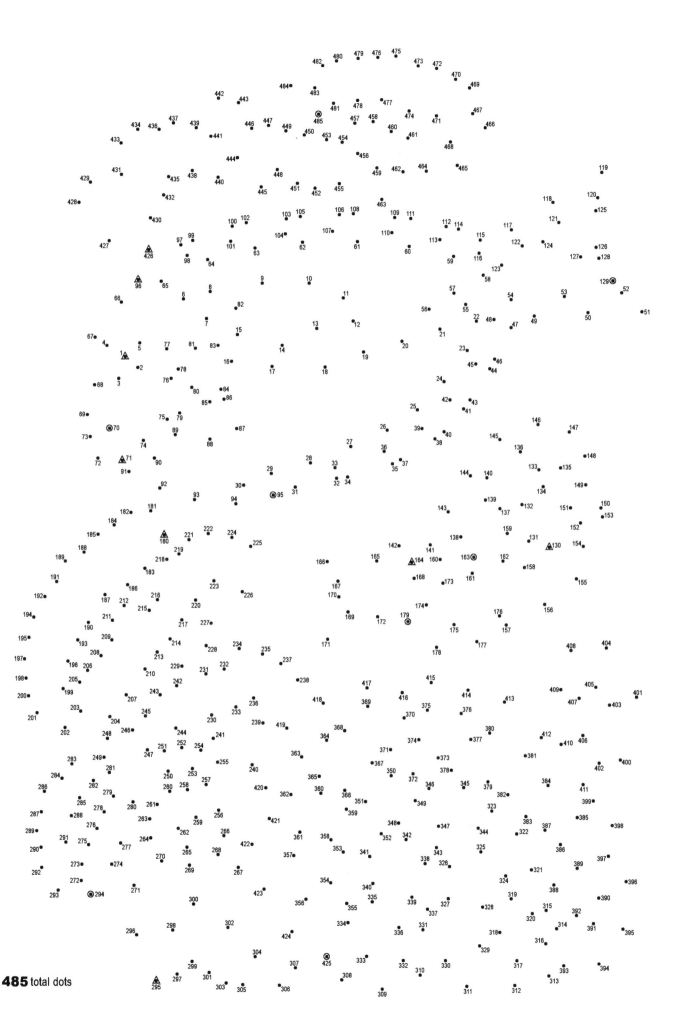

485 total dots

⚠ = Begin a new line section.

⊙ = Pick up your pen/pencil and look for the next sequential
number with the small triangle symbol next to it.

479 total dots

△ = Begin a new line section.

⊙ = Pick up your pen/pencil and look for the next sequential
 number with the small triangle symbol next to it.

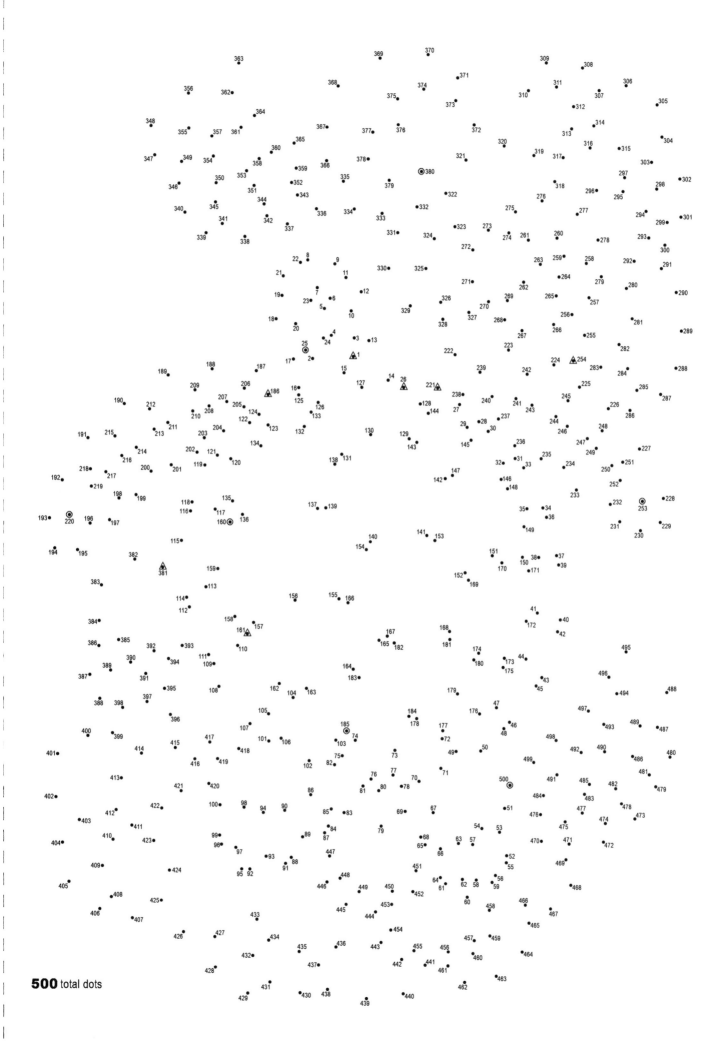

500 total dots

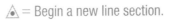 = Begin a new line section.

⊙ = Pick up your pen/pencil and look for the next sequential
 number with the small triangle symbol next to it.

385 total dots

△ = Begin a new line section.

◉ = Pick up your pen/pencil and look for the next sequential
number with the small triangle symbol next to it.

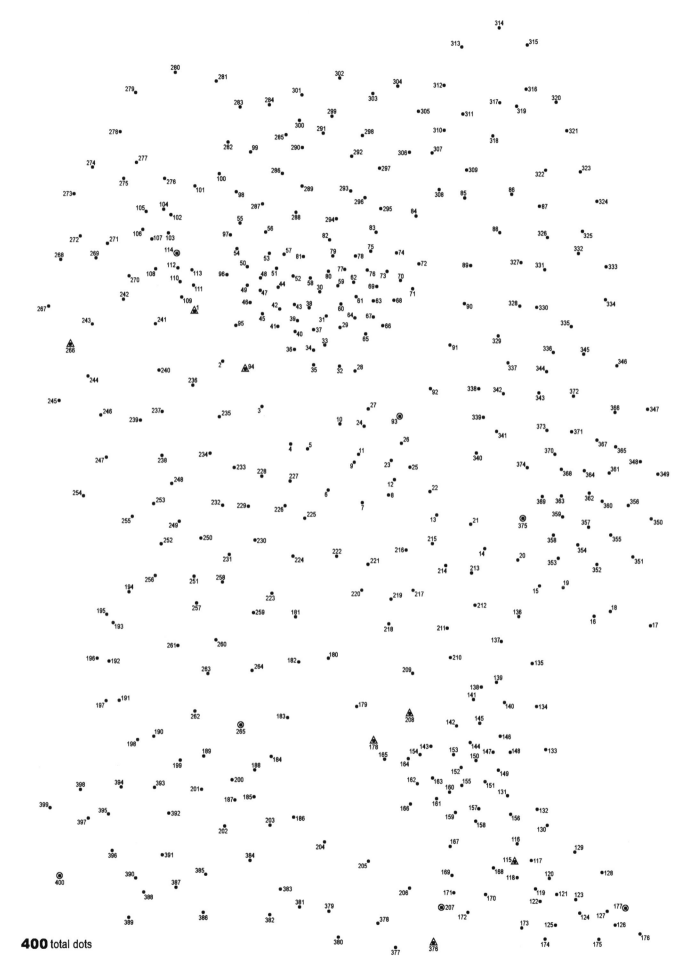

400 total dots

⚠ = Begin a new line section.

⊙ = Pick up your pen/pencil and look for the next sequential
number with the small triangle symbol next to it.

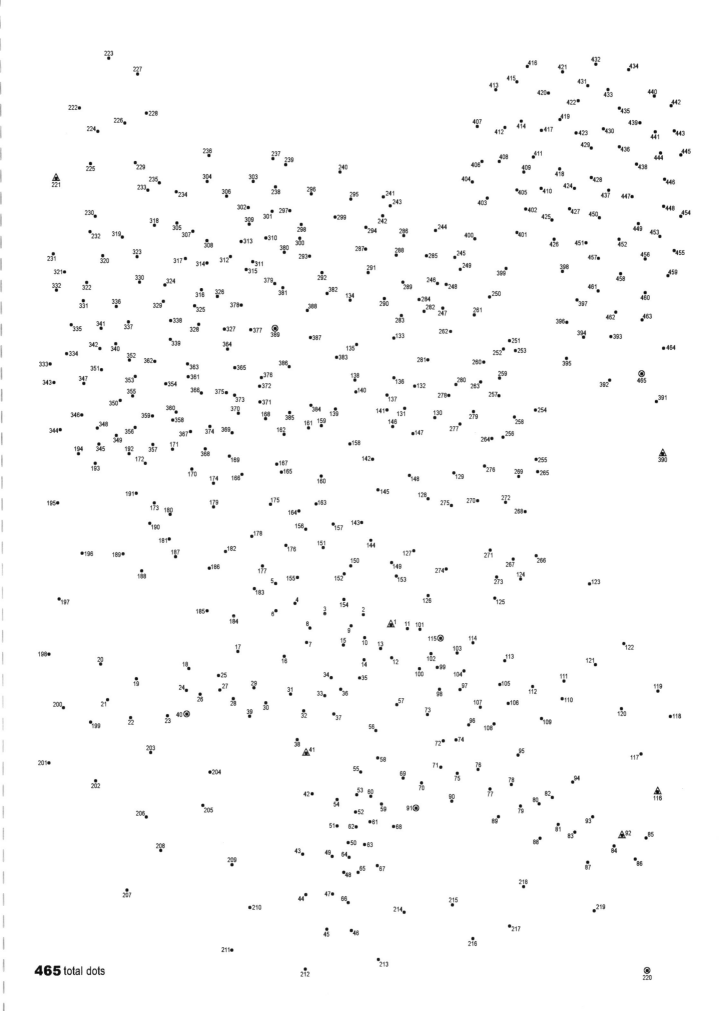

465 total dots

\triangle = Begin a new line section.

\odot = Pick up your pen/pencil and look for the next sequential
number with the small triangle symbol next to it.

375 total dots

⚠ = Begin a new line section.

◉ = Pick up your pen/pencil and look for the next sequential
number with the small triangle symbol next to it.

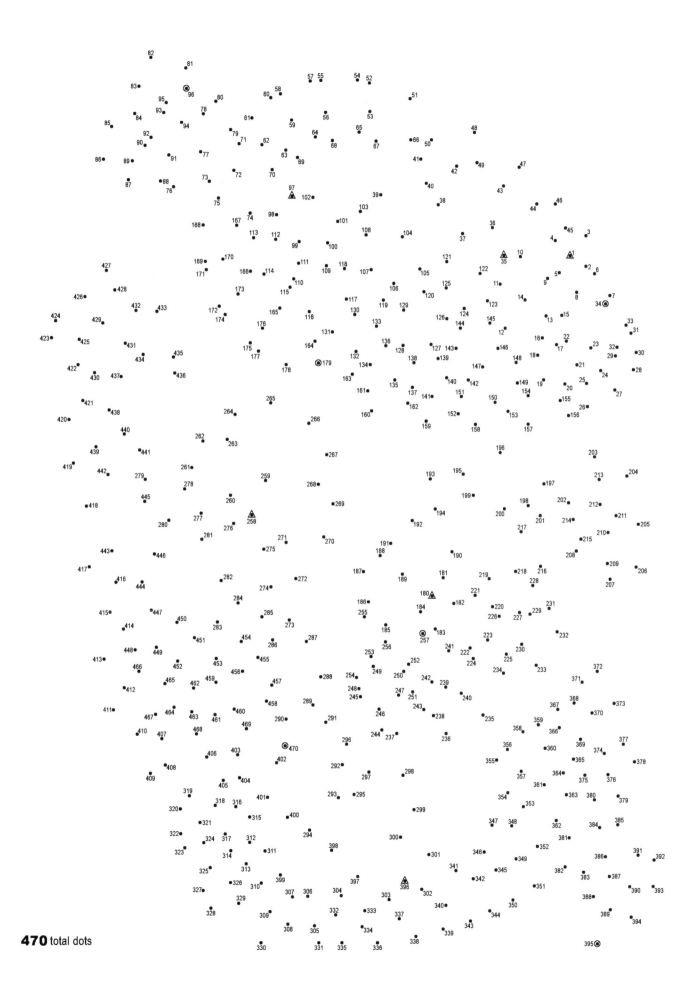

470 total dots

⚠ = Begin a new line section.

◉ = Pick up your pen/pencil and look for the next sequential
number with the small triangle symbol next to it.

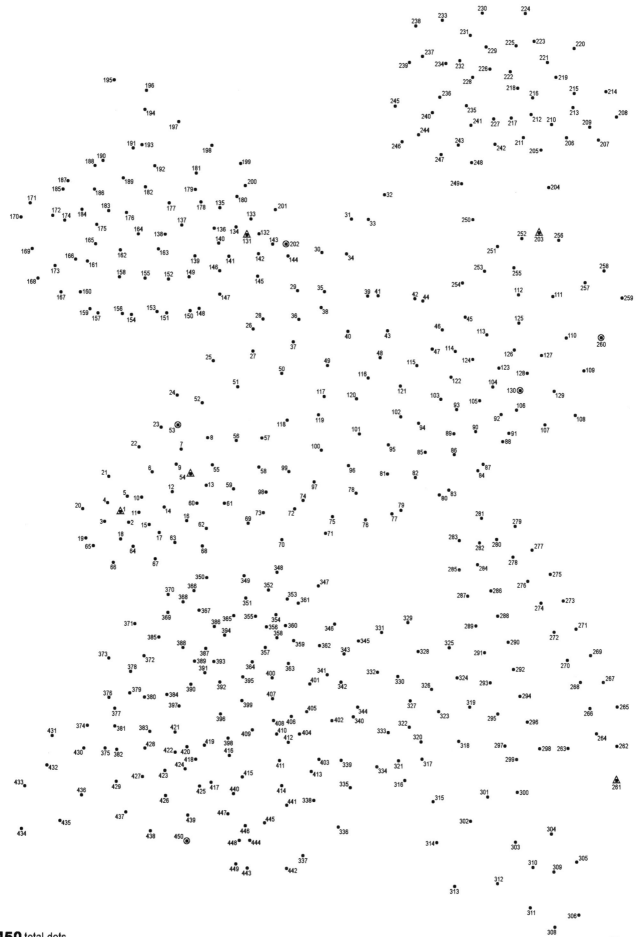

450 total dots

△ = Begin a new line section.

⊙ = Pick up your pen/pencil and look for the next sequential
number with the small triangle symbol next to it.

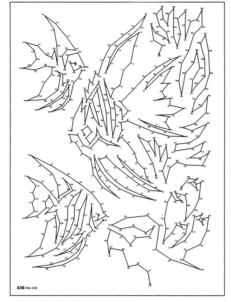

Plate 1 — Angelfish

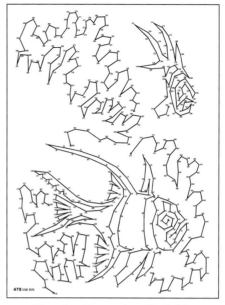

Plate 2 — Banggai cardinal fish

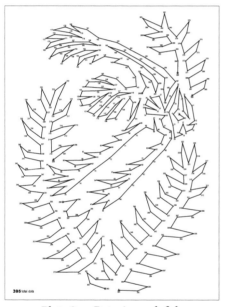

Plate 3 — Batavia spadefish

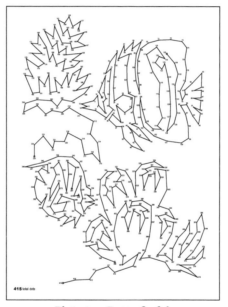

Plate 4 — Butterfly fish

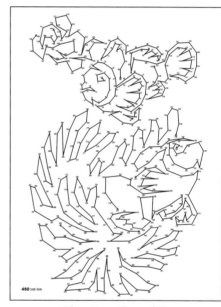

Plate 5 — Clownfish

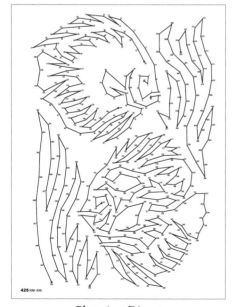

Plate 6 — Discus

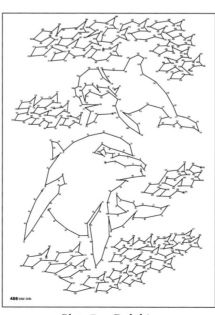

Plate 7 — Dolphin

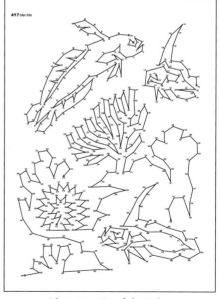

Plate 8 — Firefish Goby

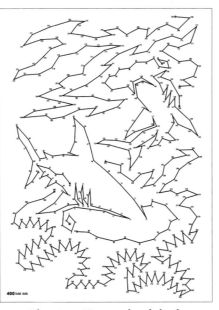

Plate 9 — Hammerhead shark

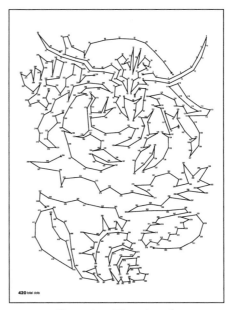

Plate 10 — Hermit crab

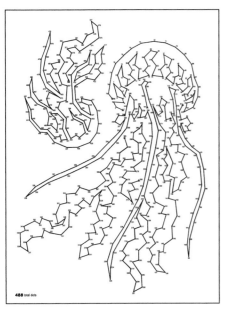

Plate 11 — Jellyfish

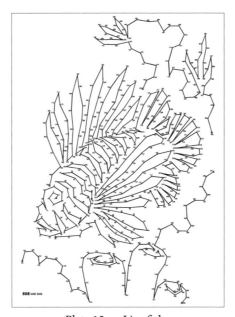

Plate 12 — Lionfish

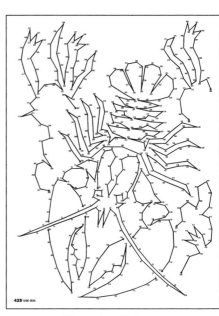

Plate 13 — Lobster

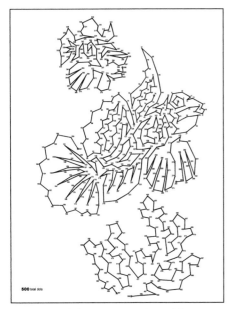

Plate 14 — Mandarinfish

Plate 15 — Moorish idol

Plate 16 — Moray eel

Plate 17 — Nautilus

Plate 18 — Nudibranch sea slug

Plate 19 — Octopus

Plate 20 — Parrotfish

Plate 21 — Pufferfish

Plate 22 — Regal tang

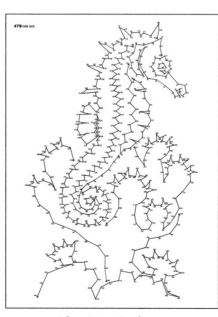

Plate 23 — Sea horse

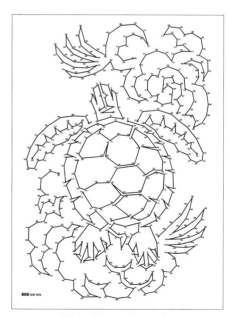

Plate 24 — Sea turtle

Plate 25 — Spotted drum

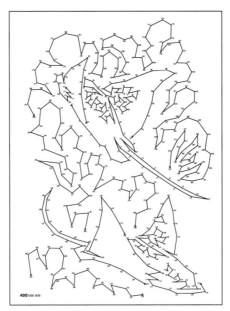

Plate 26 — Spotted eagle ray

Plate 27 — Starfish

Plate 28 — Toadfish

Plate 29 — Triggerfish

Plate 30 — Wrasse